WORKER ANT

1

Harry Gamboa Jr.

ISBN-13: 978-1493544349
ISBN-10: 1493544349

©2013, Harry Gamboa Jr.

The machinery was dismantled and sold for scrap. The building was demolished. All benefits and other funds were subsumed by critical failure of return on investment. I've picked up the largest chunk of metal and will hold it above my head while I walk towards the nearest corporate logo.

The machinery was dismantled and sold for scrap. The building was demolished. All benefits and other funds were subsumed by critical failure of return on investment. I've picked up the largest chunk of metal and will hold it above my head while I walk towards the nearest corporate logo.

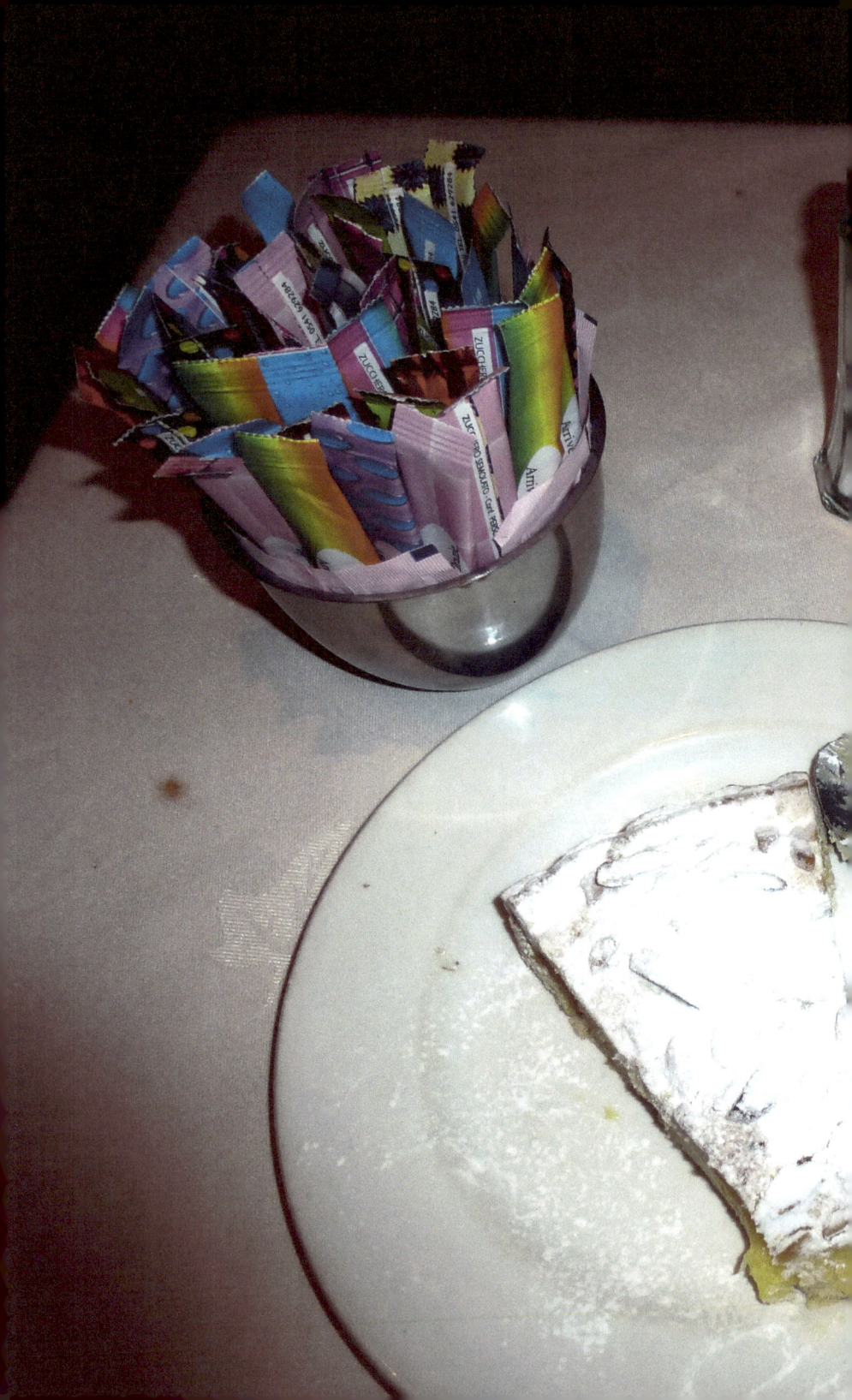

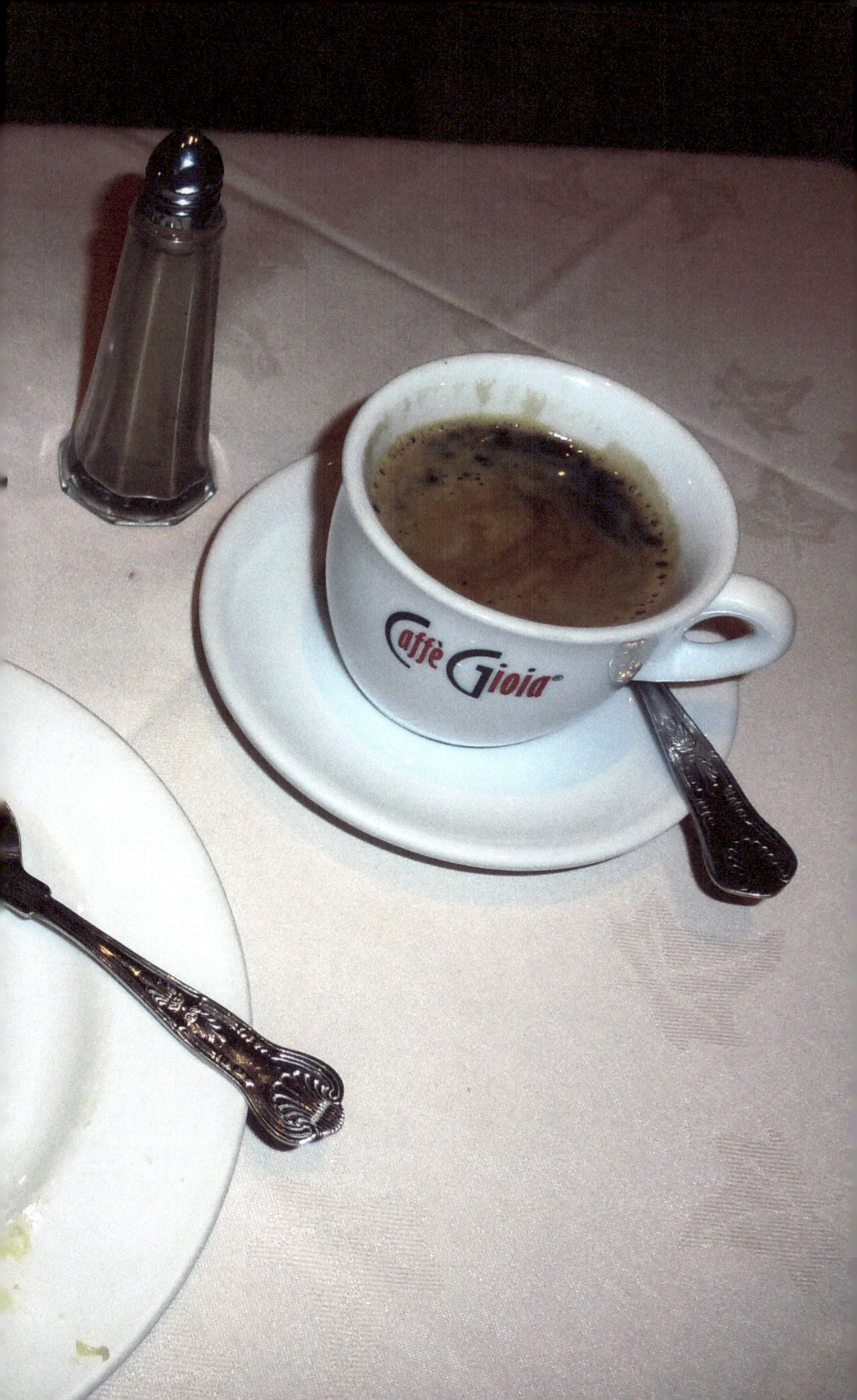

My father worked every day of his life.

A *man* placed a pink slip into his hand:

> You are hereby ordered to remove your printer's smock and to hand over the keys to all company cabinets. You have exactly 30 minute to vacate the premises.

He was forced to leave without his last paycheck and was cheated out of full retirement.

The *man* was a hoodlum in a shirt and tie who then disappeared into the corporate hierarchy.

He died without a cent to his name.

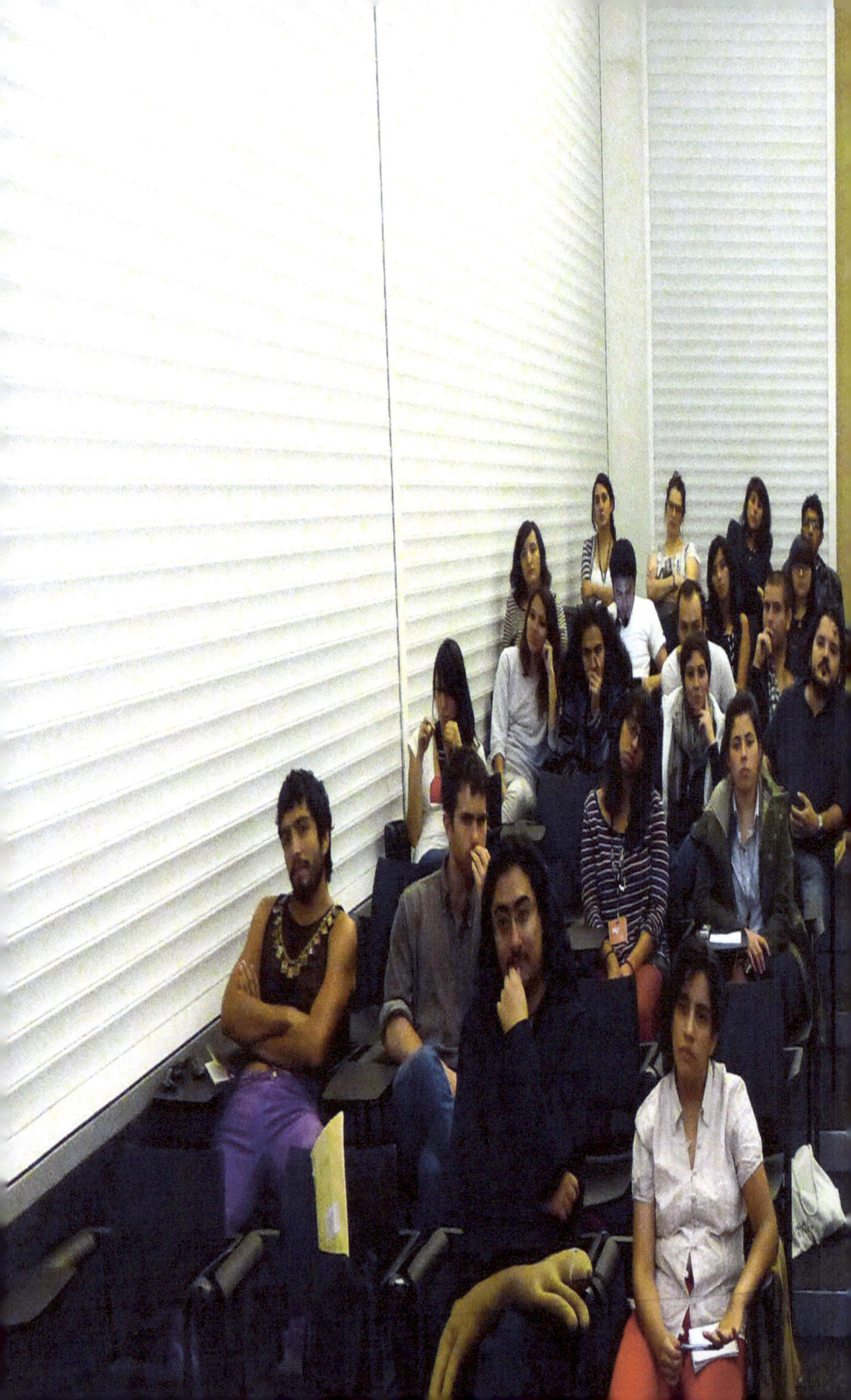

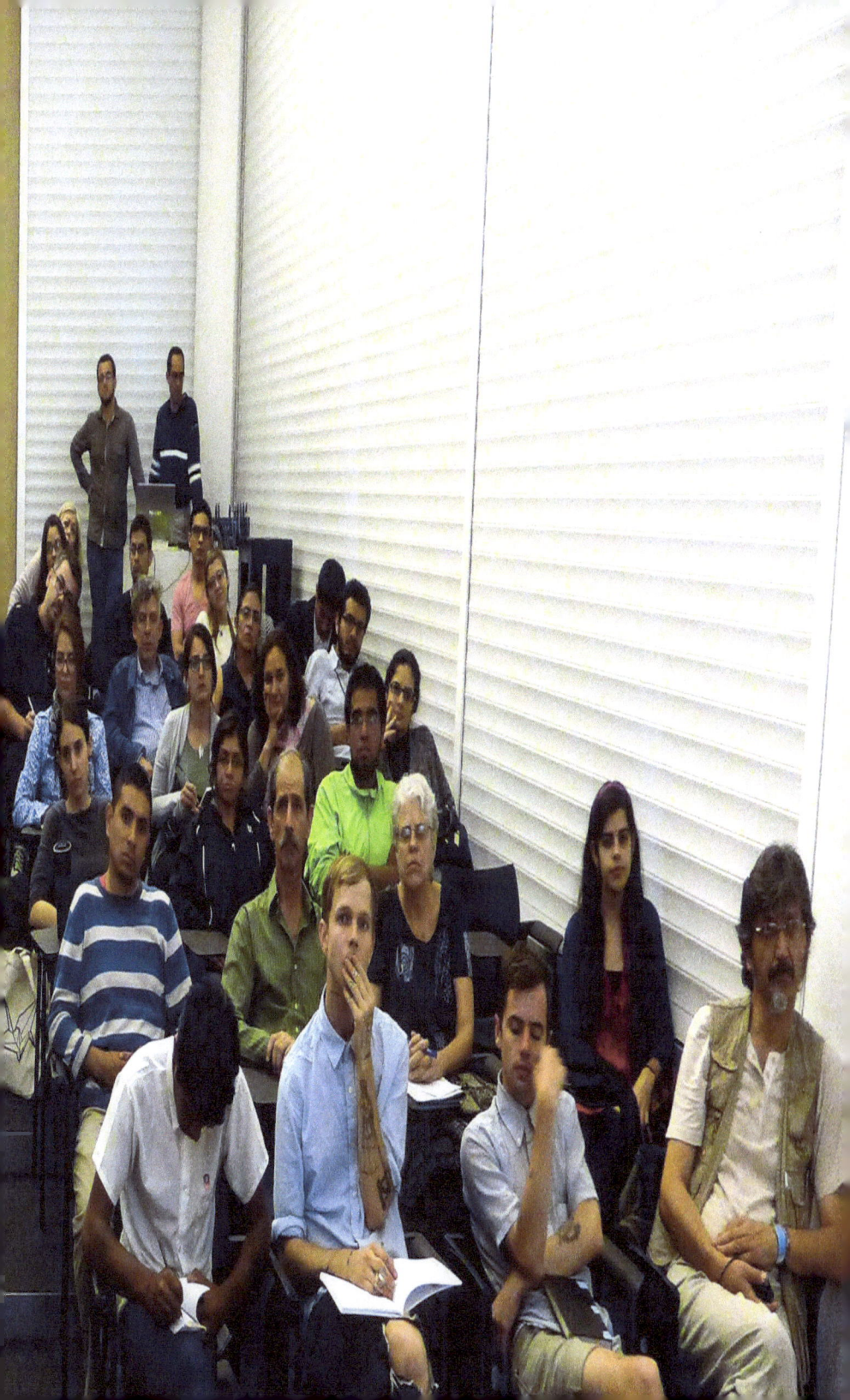

THEM:
YOU ASSUME A STANCE THAT OFFENDS OUR UNDERSTANDING OF CONTEMPORARY EVERYTHINGISM. IT HAS SOMETHING (IF NOT EVERYTHING) TO DO WITH HOW THE WORLD CRUMBLES UNDER THE AUSPICES OF PROGRESS.

MODERATOR:
PUT THE GUN DOWN.

YOU:
WE ARE ALL DESTINED TO PLAY IN A BLACK HOLE FOR INFINITY. THERE IS NO PROBLEM WORTH SOLVING.

MODERATOR:
PUT YOUR CLOTHES BACK ON.

YOU:
CELLOPHANE JOCKSTRAP, ALUMINUM BRA, PANTS ON FIRE, PATENT LEATHER PLATFORM SHOES, NOW THAT'S FASHION.

THEM:
WE AREN'T RESPONSIBLE FOR DISRUPTIVE ELEMENTS IN THE GROUP. THE ARTWORKS ON DISPLAY DO NOT MATCH THE VISUAL REPRESENTATIONS IN PRINT, ONLINE, OR IN MEMORY. DO YOU HAVE NO RESPECT FOR VALIDATION?

YOU:
I HAVE MANY CHILDREN AND IT IS STILL NO PROOF THAT I'VE EVER BEEN SEXUALLY ACTIVE.

MODERATOR: THERE IS ONE PARTICULAR PHOTOGRAPH THAT HAS APPEARED ON THE COVER OF MAJOR ART MAGAZINES, ON TV, AND IN MANY SCHOLARLY JOURNALS. EACH TIME IT APPEARS, THE DEAD MAN LOOKS EVEN DEADER THAN HE DID BEFORE. HOW DO YOU ACCOUNT FOR THAT?

YOU: HOW ABOUT IF I PLAY THE MODERATOR ROLE FOR A MINUTE TO THEN ALLOW YOU TO ASK QUESTIONS?

MODERATOR: SHUT THE DOORS AND KEEP QUIET.

THEM: YOU DON'T LOOK LIKE AN ARTIST. NO OBVIOUS SIGNS OF ABJECT POVERTY NOR OF UNIMAGINABLE WEALTH. WHAT INSPIRES YOU TO CONTINUE UNABATED IN THE NETHERWORLD?

YOU: I SAW A PERSON BECOME A NONENTITY IN AN INSTANT, I ONCE HEARD A BEAUTIFUL VOICE WHISPER NOTHINGS IN MY EAR, I'VE TASTED BITTER LOVE IN THE DARK, THEREFORE I AM.

THEM: LET US ALL OUT.

MODERATOR: SHOOT TO KILL. DO IT NOW.

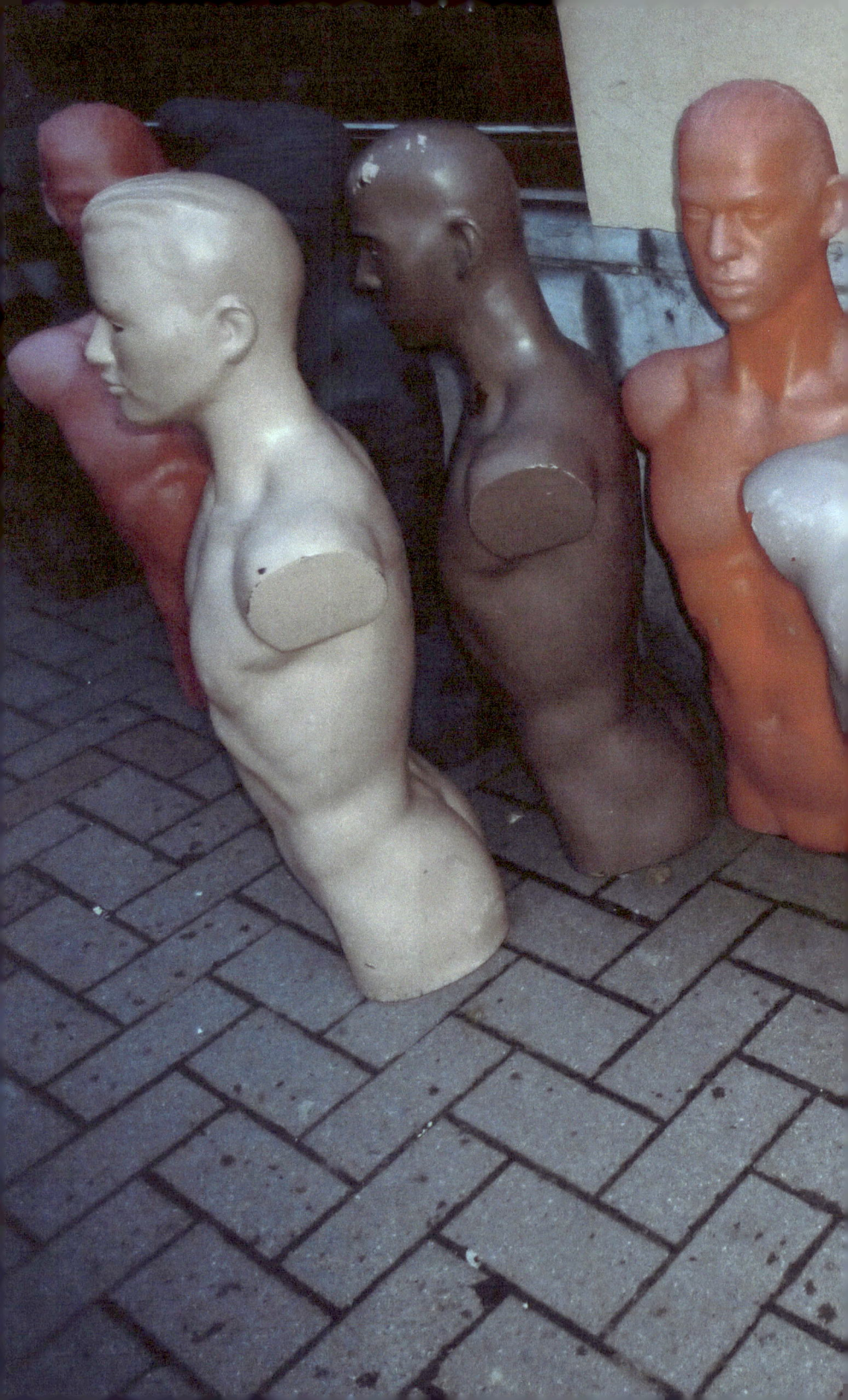

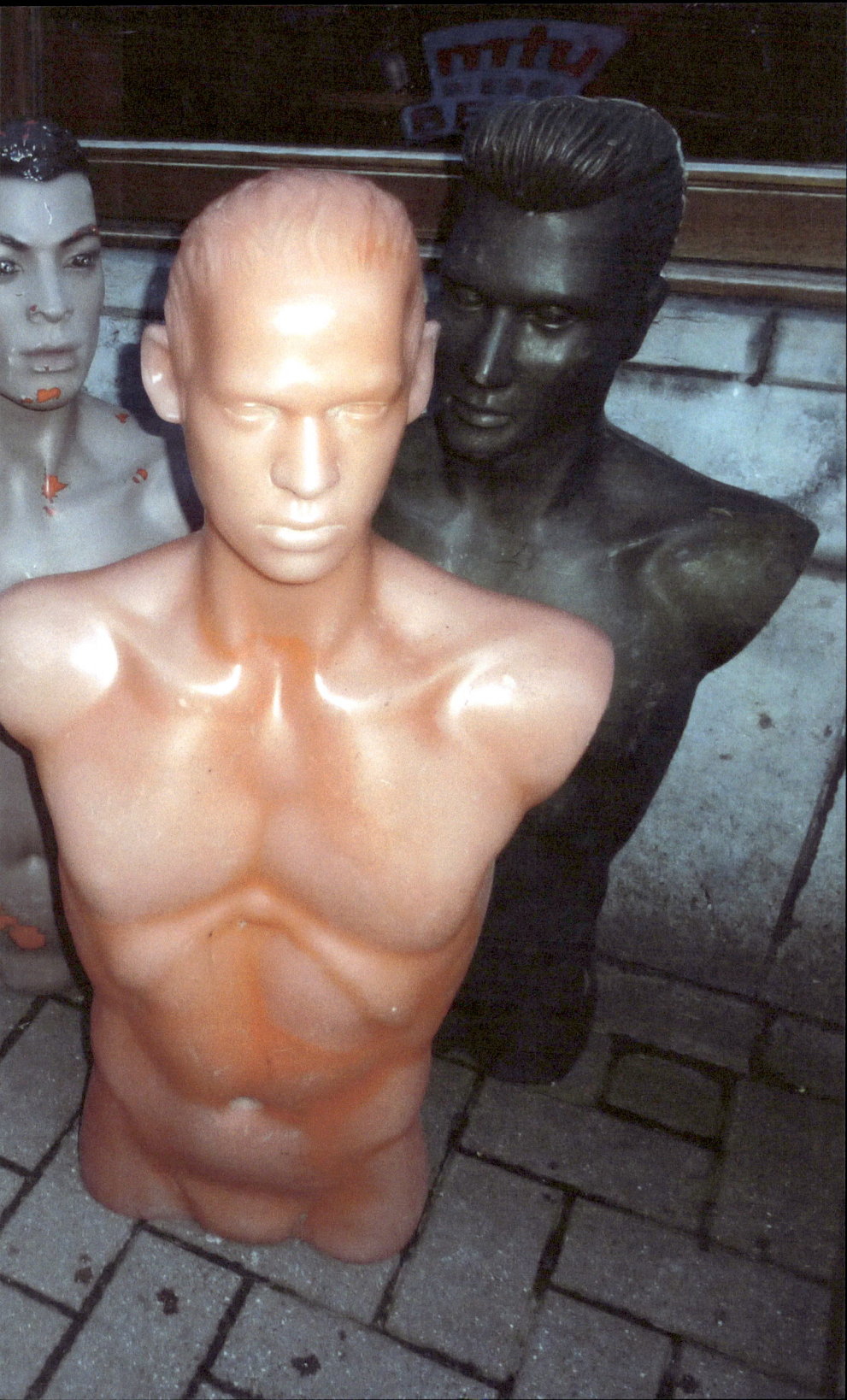

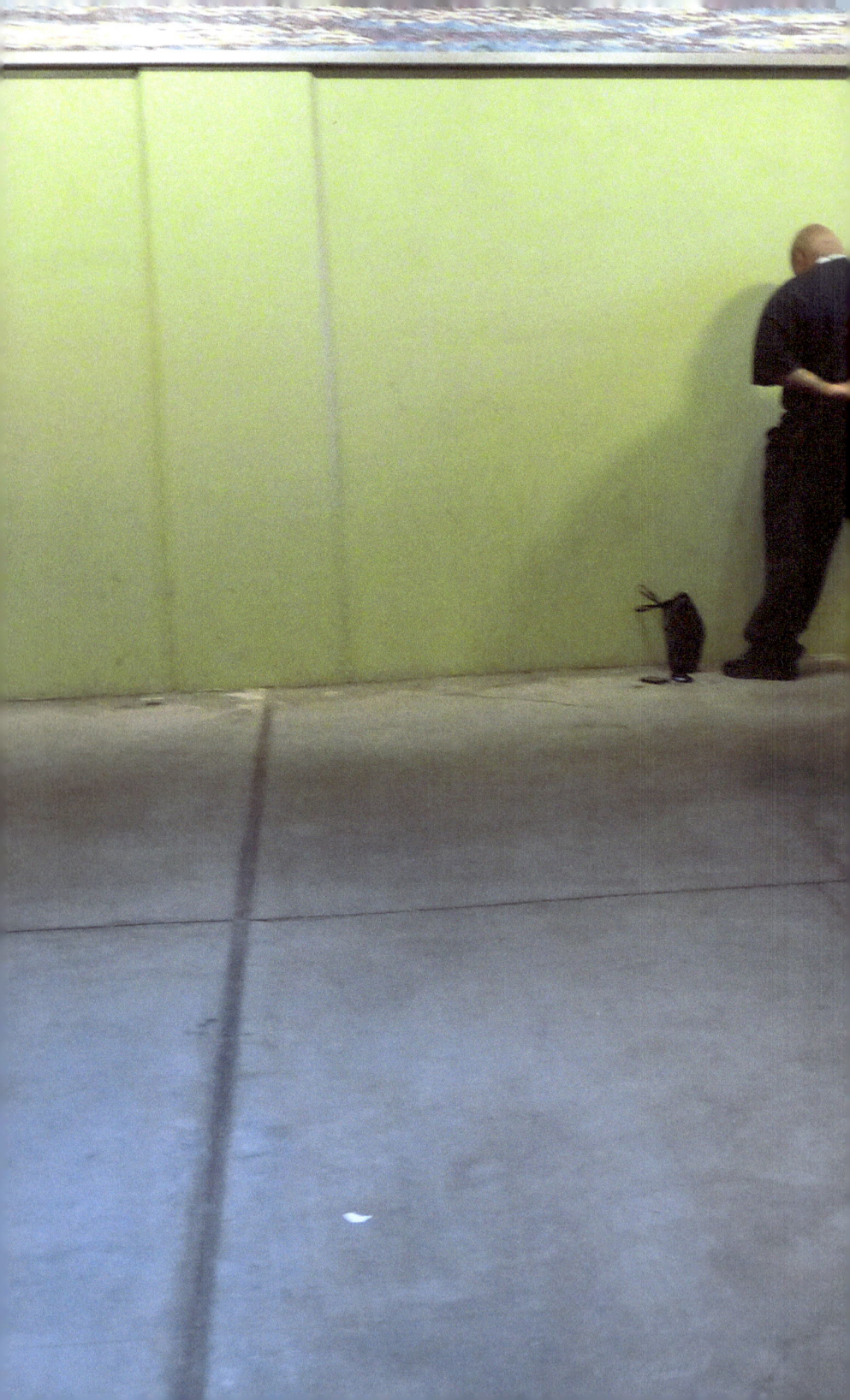

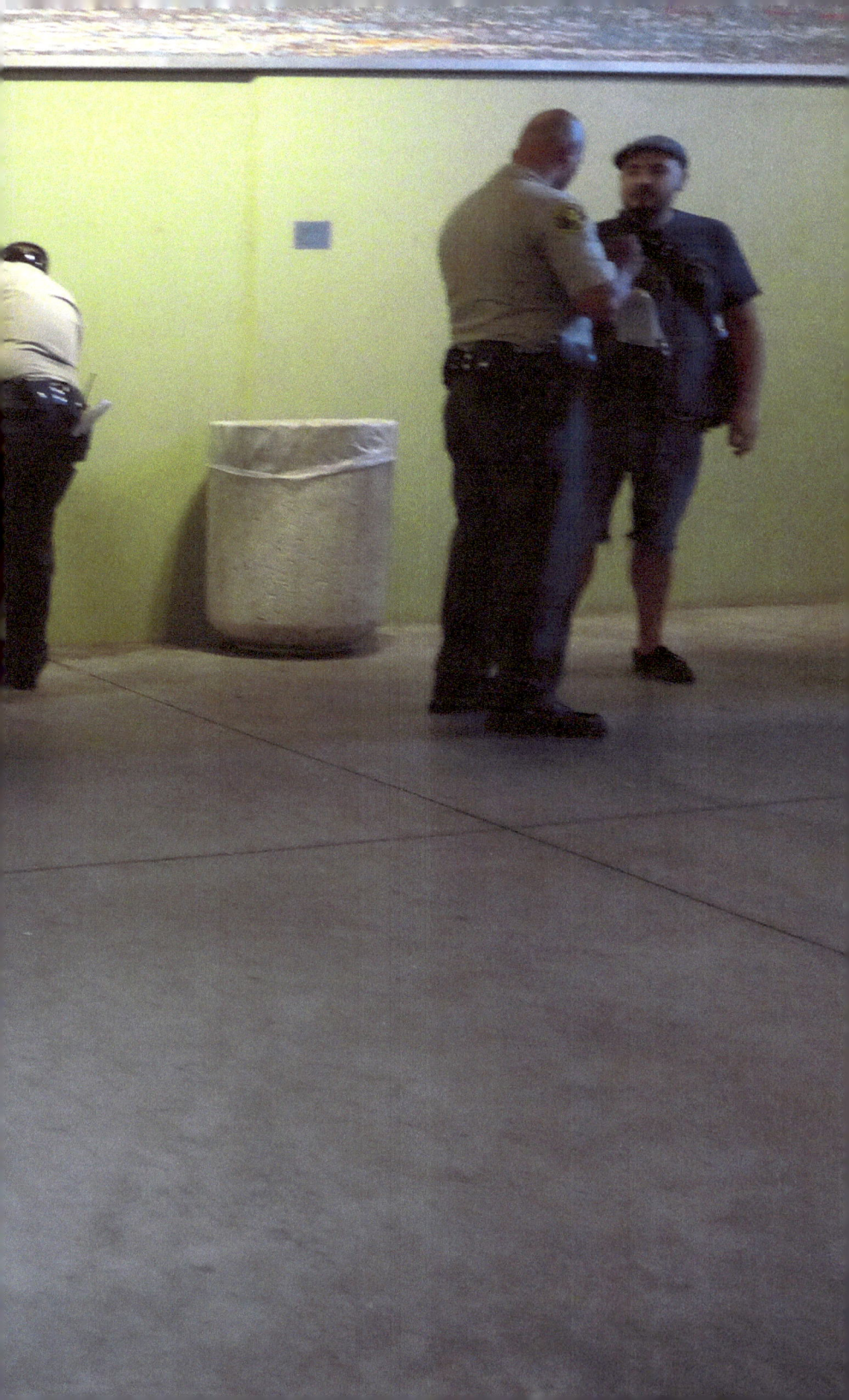

5:00 a.m.
Wake up. Exercise. Shower.
Breakfast: Proteins, carbohy-
drates, chile, cinnamon, cocoa,
vitamins. All items in backpack.

6:00 a.m.
Out the door.

6:15 a.m.
Board bus. Read newspaper,
book, magazine.

6:30 a.m.
Board commuter rail. Write.

7:15 a.m.
Café, double espresso.

7:30 a.m.
Board Metro Red Line.
Record subway audio.

8:00 a.m.
Board bus. Write list.

9:30 a.m - 3:15 p.m.
Lecture four classes, drink water.

4:20 p.m.
Board Metrolink train.

5:00 p.m.
Meetings, downtown L.A., take photographs. Dark chocolate.

8:00 p.m.
Board Metro Red Line + commuter rail + bus + walk.

9:30 p.m.
In the door. TV dinner.

11:00 p.m.
Sleep.

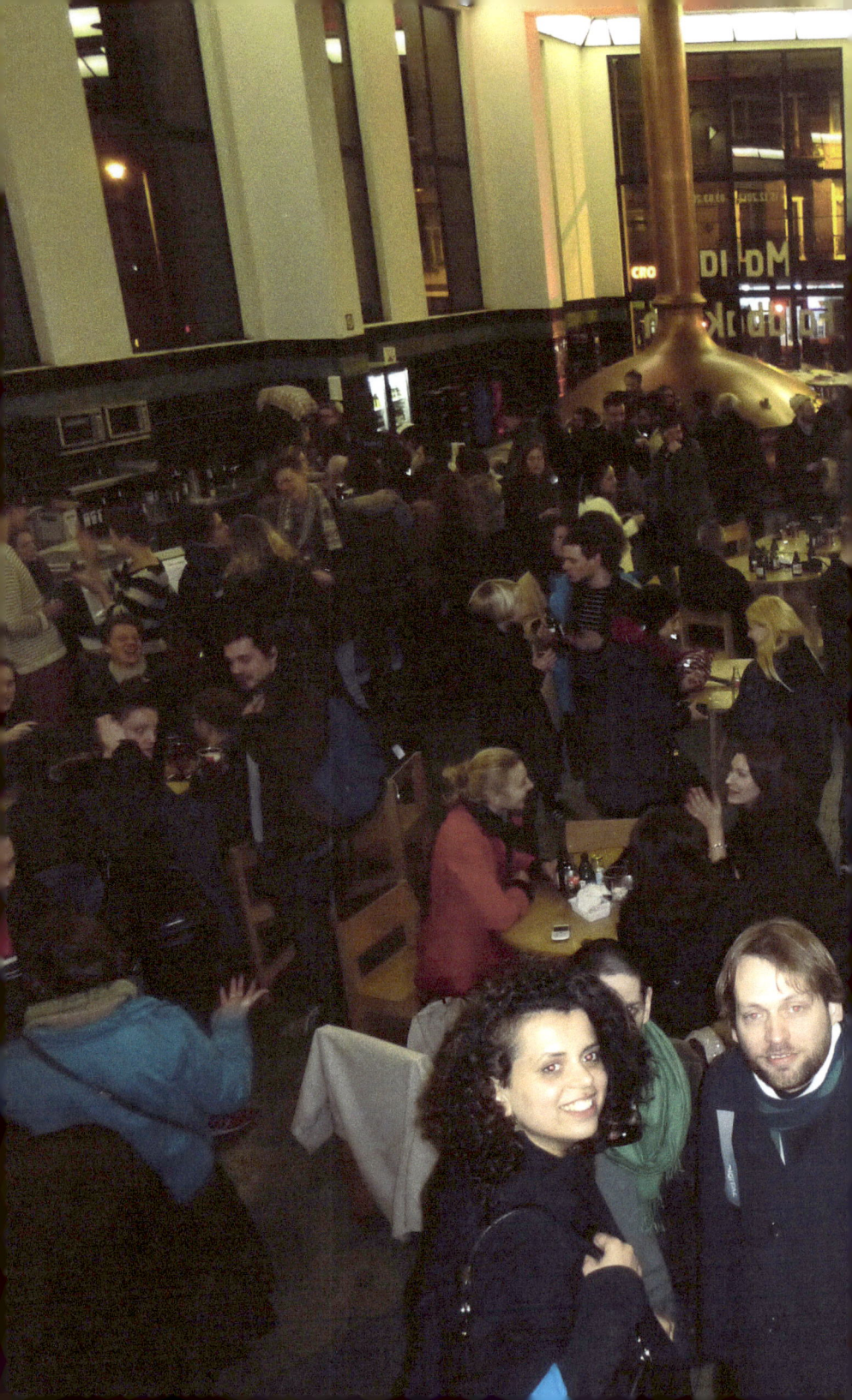

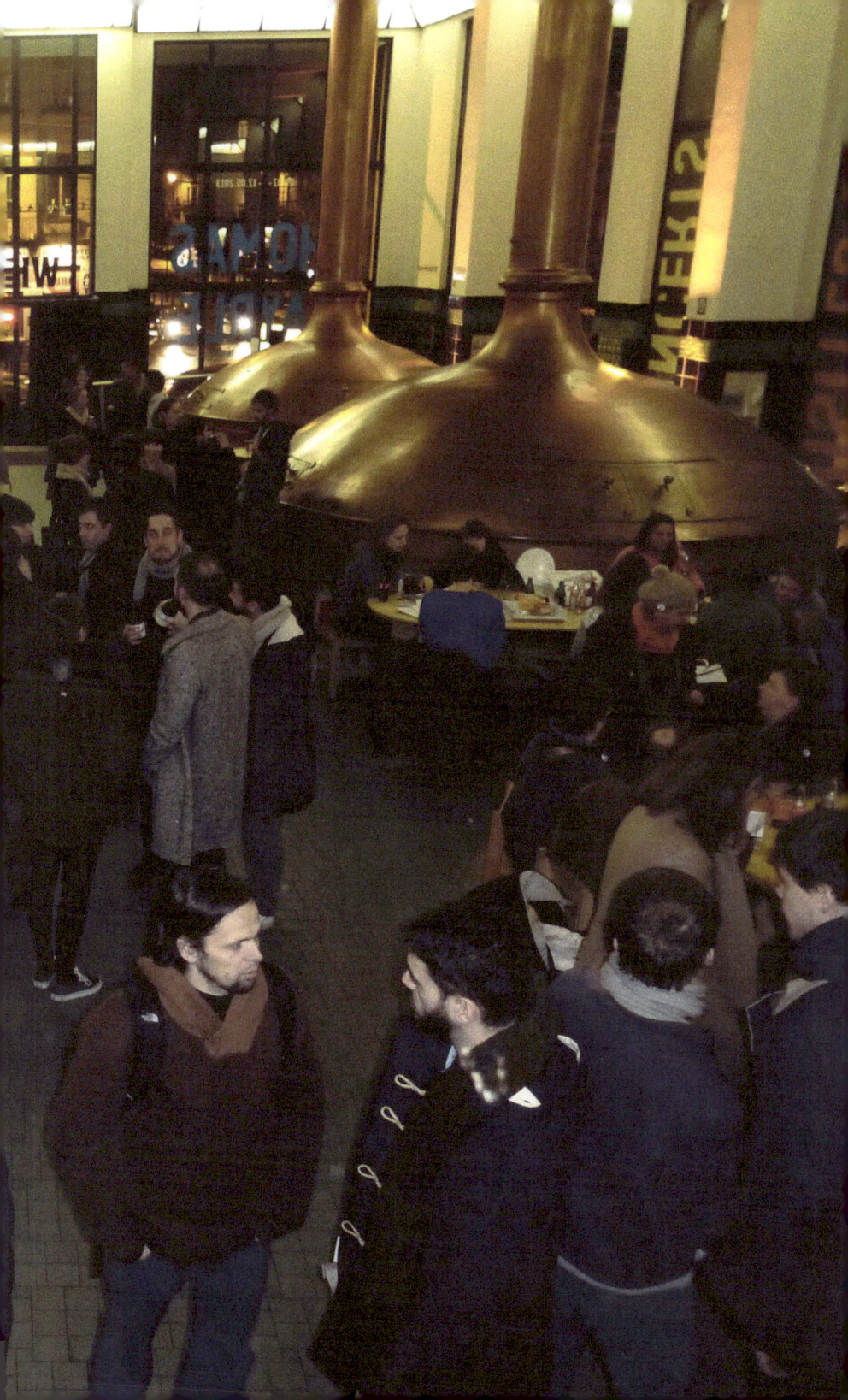

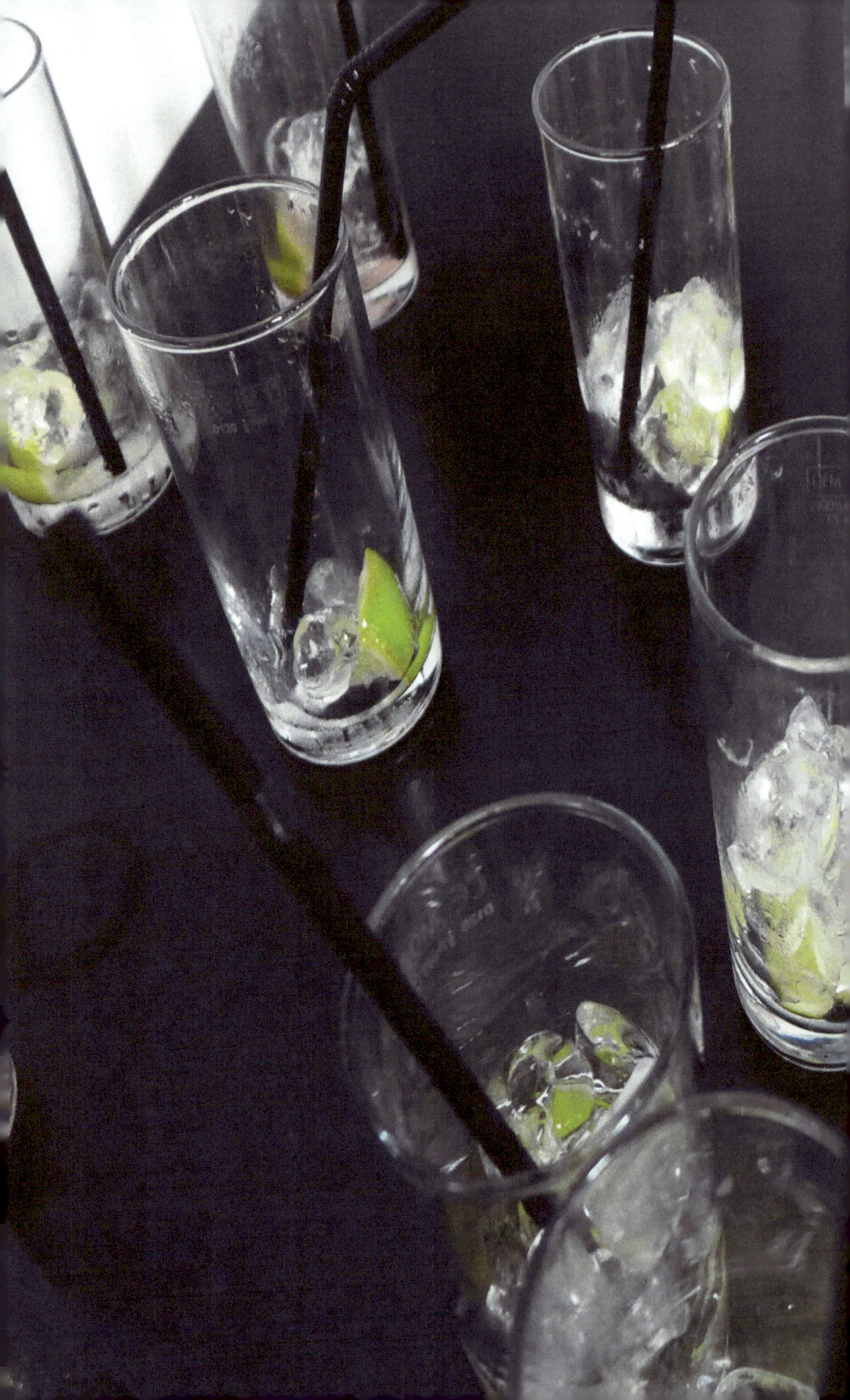

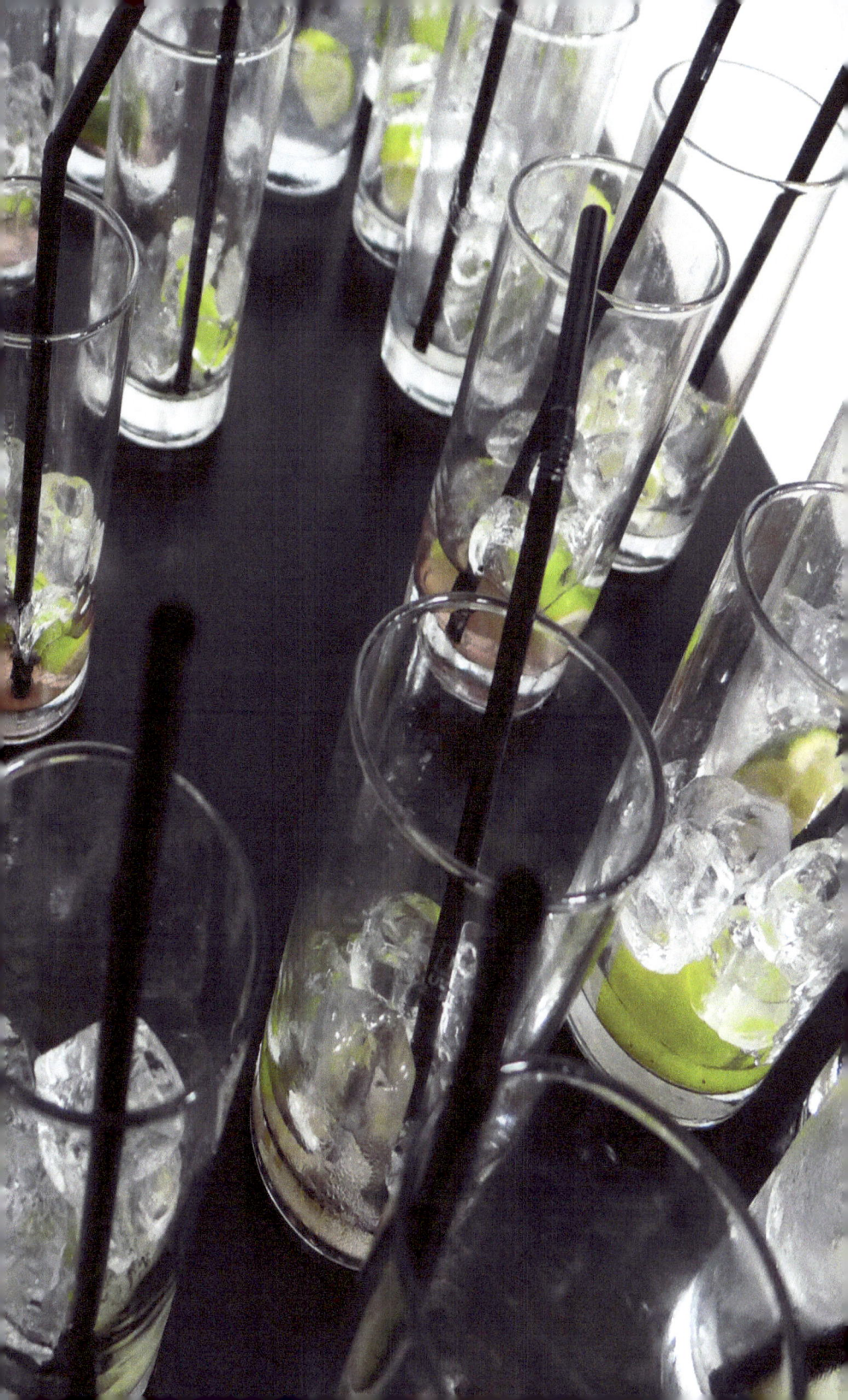

The drinks were freely distributed and all was consumed within an hour. The aftertaste of lime caused everone to remark how wonderful it all is to live and laugh while dancing in the streets. A few stumbled and leaned against the wall. A man removed his shoes and revealed feet that had been beaten. A woman exposed her back that had welts and violet bruises. The music was very loud. Post-punk. Virtual pain. The artwork reflected an era long past. A young couple wore matching red platform boots that were stolen from the nearby castle. They would have been hanged a hundred years ago. The artists were in their respective corners. One looked like he had see it all before. The other had a guard at her side. Telepathy had ceased long ago. Fresh drinks and the clinking of ice cubes filled the air. An echo frozen in memory. The young couple licked the woman's brutal wounds.

A young man painted his body in bright shades of yellow, orange, and red. He claimed that his ancestors were of superior stock. He was quickly ejected and immediately returned drenched in blood. He wasn't bleeding and cleansed himself using expensive vodka as an appropriate wash. A rumor was circulated that caused alarm among those who were in their 50's and 60's. The rioters had been slaughtered and now it was time for those who inspire thought and action. The hope that it was all behind them would be disproven when teargas filled the galleries. Batons hit their marks eliminating recognizable facial traits until everyone blended into a silent homogenous crowd. The people were ordered to march in unison while swabs of DNA would be publicly extracted via exposed orafices. The new order would be a matter of ceaseless work for all. The crony-capitalists resorted to old tricks.

Dessert
London
4–5

Audience
Mexico City
8–9

Mannequins
Antwerpen
12–13

Metro Bust
Los Angeles
14–15

Reception
Brussels
18–19

Drinks
Nottingham
22–23

Special Thanks

Nottingham Contemporary
Museo Universitario Arte Contemporáneo
South London Gallery
Universitair Centrum Sint-Ignatius Antwerpen
California Institute of the Arts
Nico Dockx
Isabel Tesfazghi
Stefan Wouters
Orlando Tirado

www.harrygamboajr.com

www.ingramcontent.com/pod-product-compliance
Lightning Source LLC
Chambersburg PA
CBHW040915180526
45159CB00010BA/3078